How to Draw
Kawaii Creatures

In simple steps

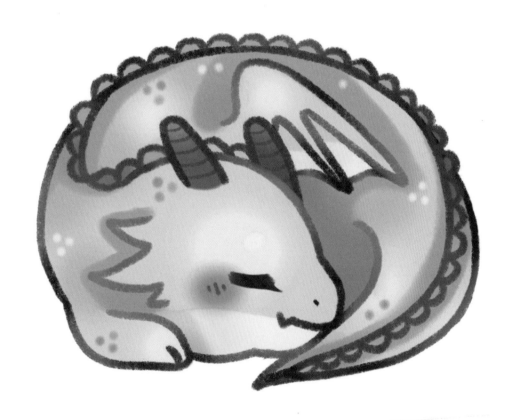

First published in 2023

Search Press Limited
Wellwood, North Farm Road,
Tunbridge Wells, Kent TN2 3DR

Reprinted 2023

ISBN: 978-1-80092-122-1
ebook ISBN: 978-1-80093-111-4

FSC
www.fsc.org

MIX
Paper | Supporting responsible forestry
FSC® C012521

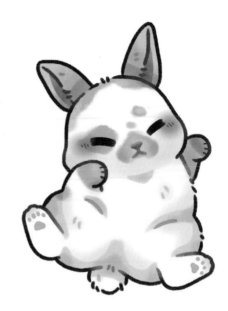

Dedication

I would like to dedicate this book to my fellow artists on social media. Thank you for adding beauty to this world through your art and endlessly inspiring me to draw.

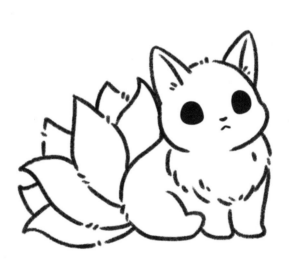

Illustrations

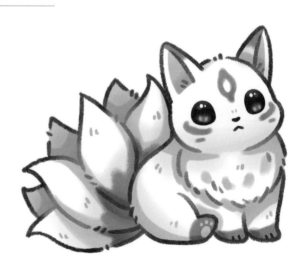

How to Draw

Kawaii Creatures

In simple steps

Aria Wei

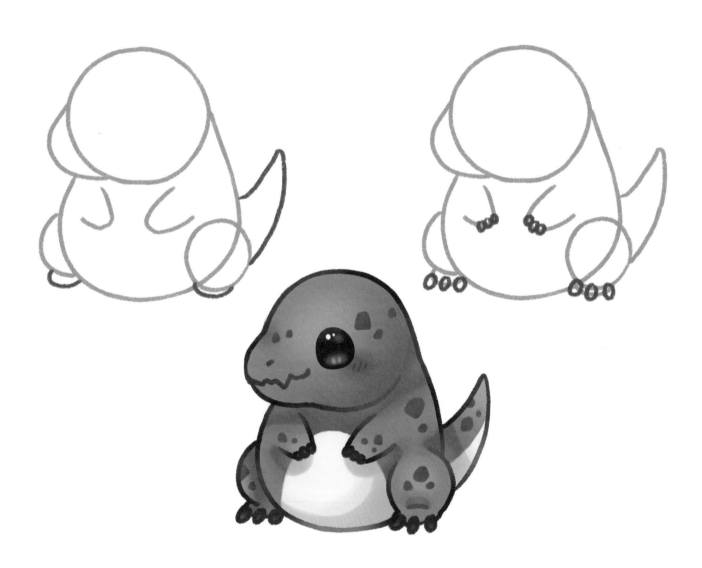

Search Press

Introduction

'Kawaii' is a term that originates from Japan, and refers to things that are cute, adorable and often childlike. Thanks to the ever-growing popularity of anime and manga, kawaii is an aesthetic that has gained popularity in the last few years and it can be applied to anything, especially animals. So if you want to learn how to draw your own kawaii creatures, this simple how-to-draw book is for you!

This book presents various kawaii creatures with adorable features and unique charms. There are twenty-eight different illustrations available: cats, crocodiles, penguins, unicorns and more. Each illustration is developed in eight steps, in which I guide you from a rough sketch made of basic shapes to a clean black outline, then finally on to a fully finished, coloured image. Each stage is broken down so everything is easy to follow, making this book suitable for individuals of all ages and abilities. The first step, with just the basic shapes, is shown in blue, and in each subsequent step, the new lines are shown in red so you can see what has been added. Of course, you don't need to use two colours in each step; this is just for clarity. Just follow the guidelines and you'll be creating your own kawaii creatures in no time!

I illustrated everything using an illustration app on a tablet with a digital pencil and the app's built-in 6B pencil brush. However, these illustrations are equally replicable with a piece of paper, a pencil and an eraser. For those using the pencil-and-paper method, please make sure to keep your sketches light so that everything can be easily erased or modified. I recommend using H-grade pencils such as the 3H or 2H for sketching because they produce lighter, finer sketches. Once you have finished drawing the basic shapes for the sketch, you can use darker B-grade pencils or pens to form the final outline of the image. Finally, the colouring process is incredibly flexible: you can colour your picture with coloured pencils, watercolour, markers – basically anything you want! The most important part of this drawing process is to let your creativity run free.

Happy drawing!

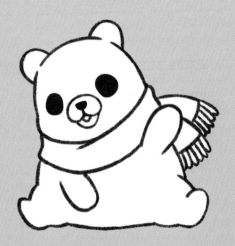

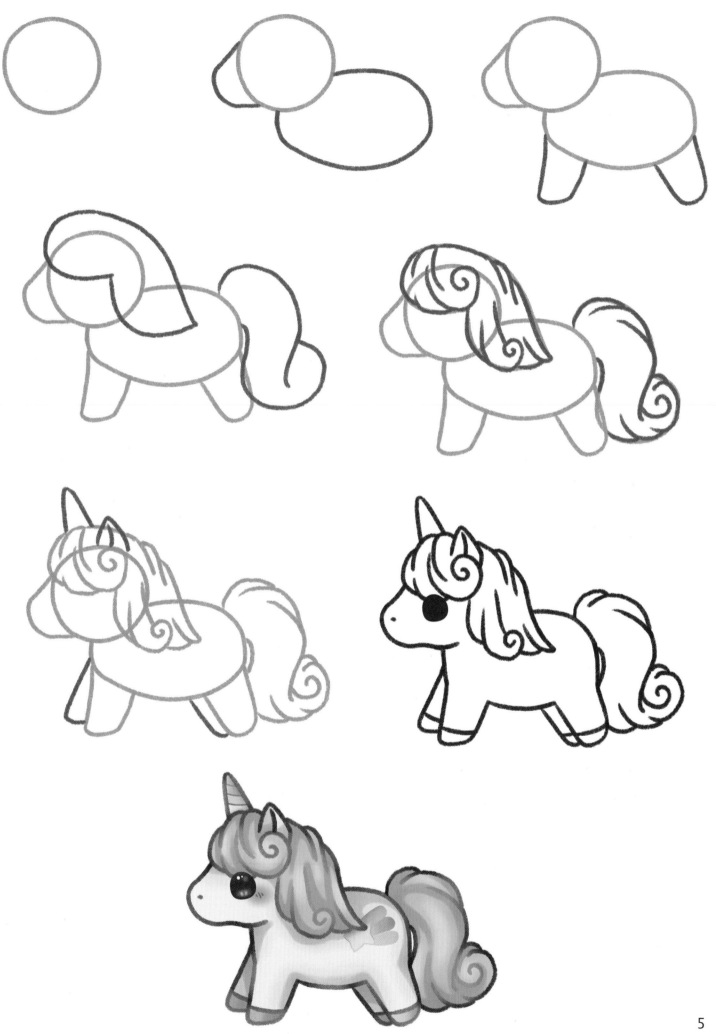

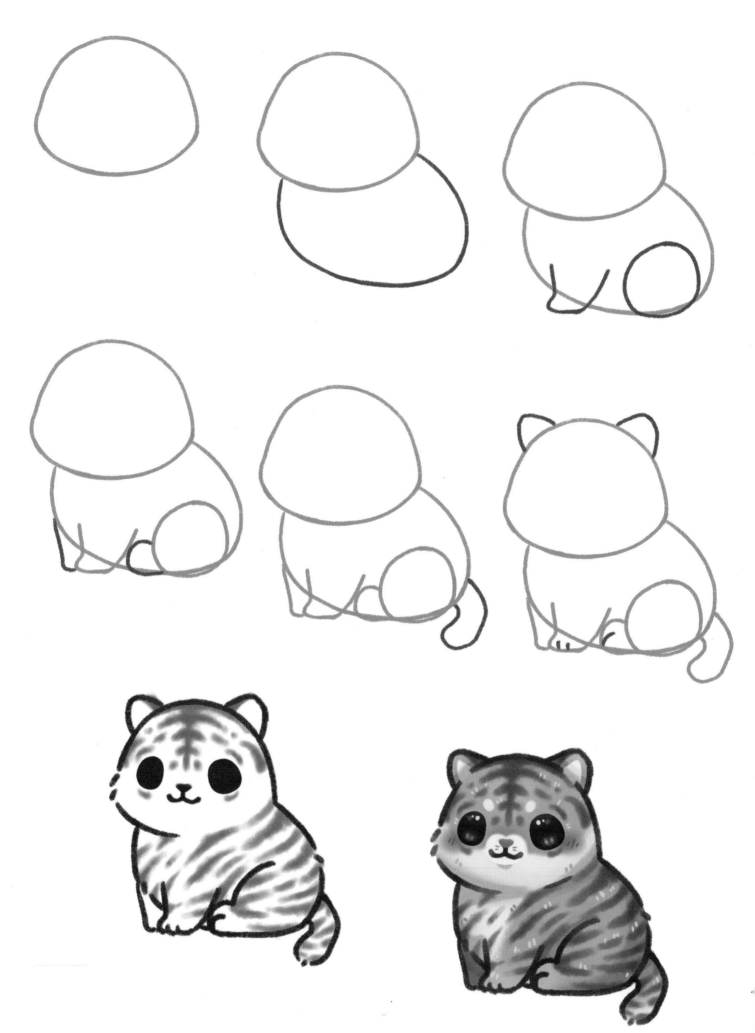

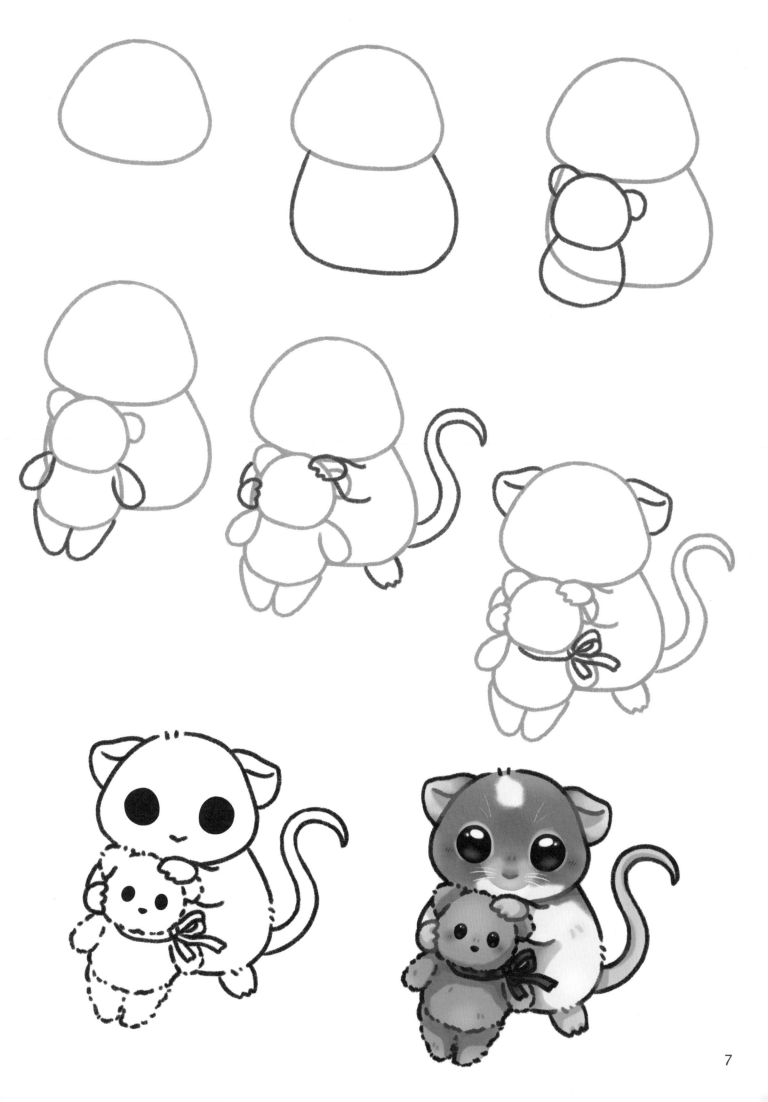

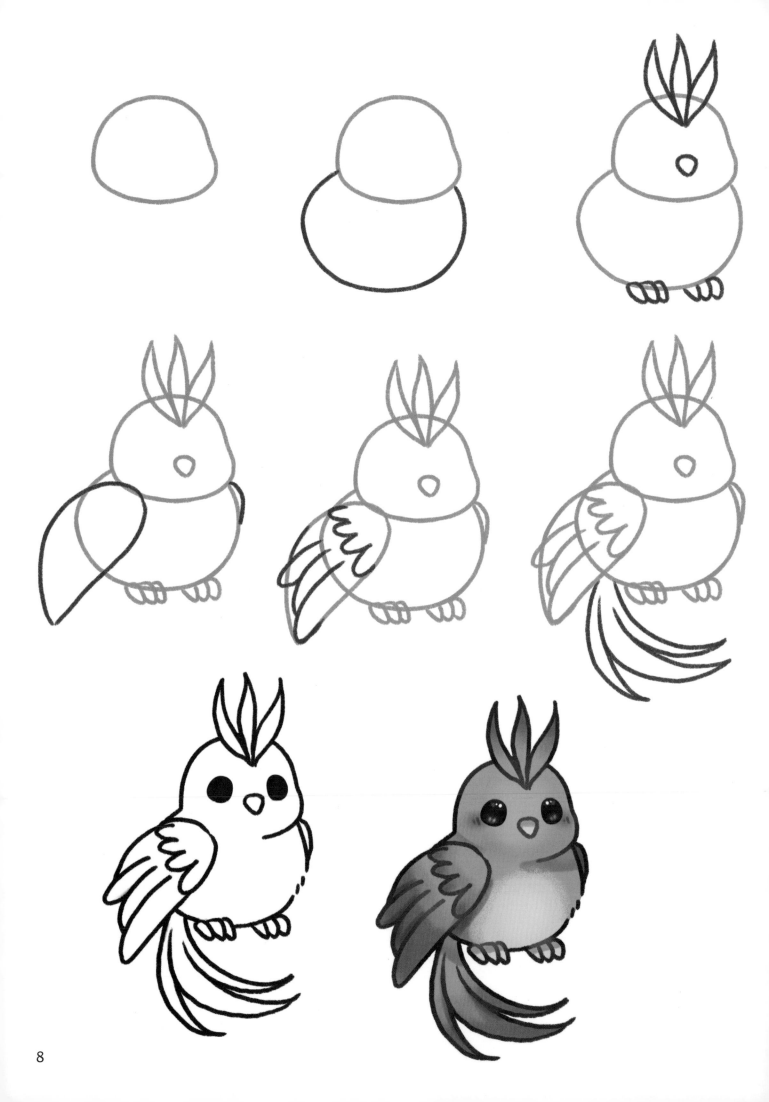

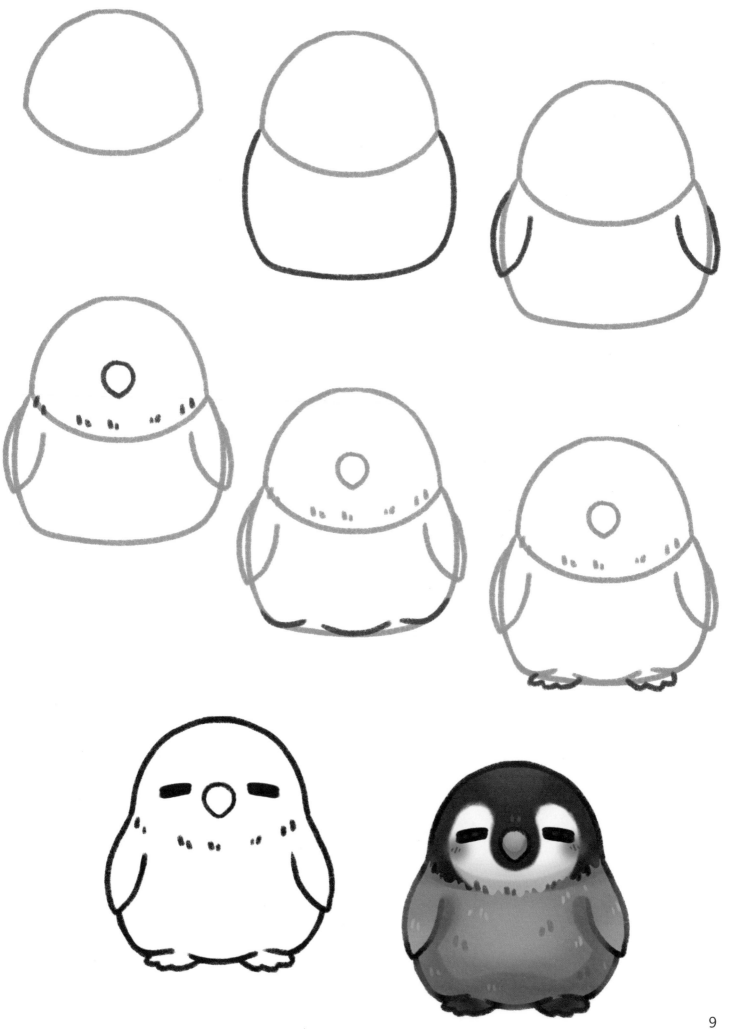

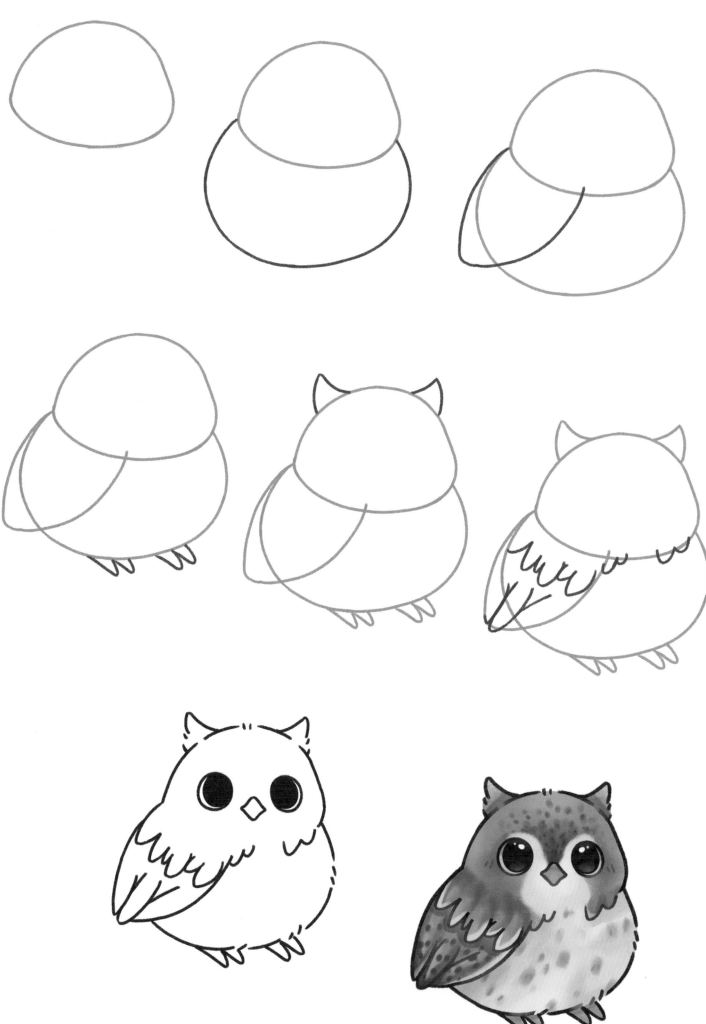

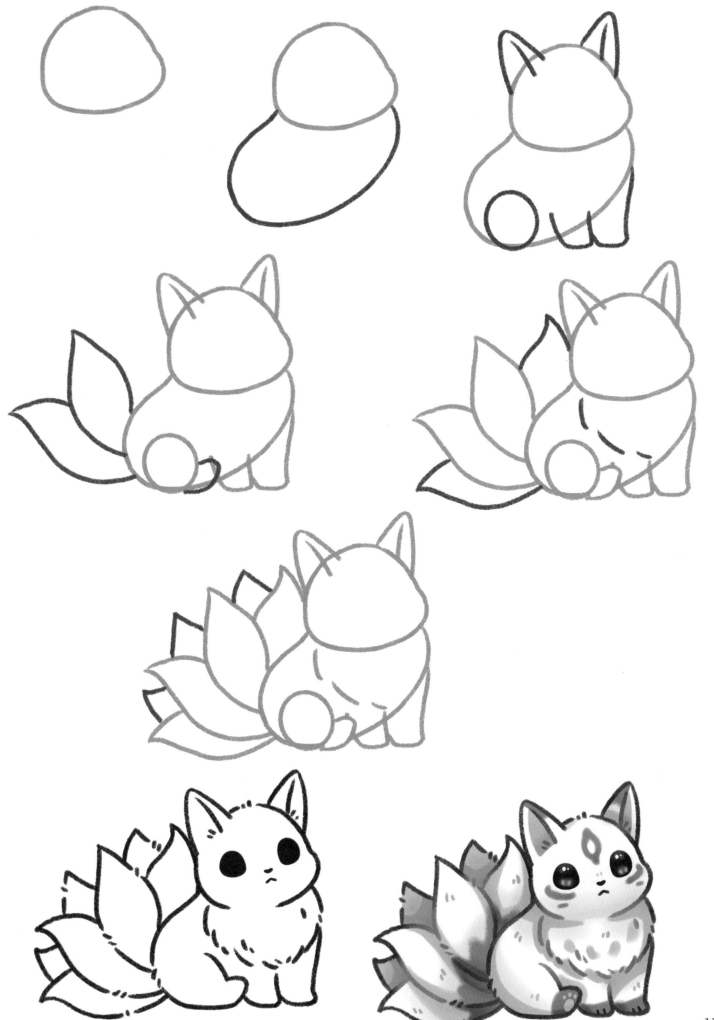

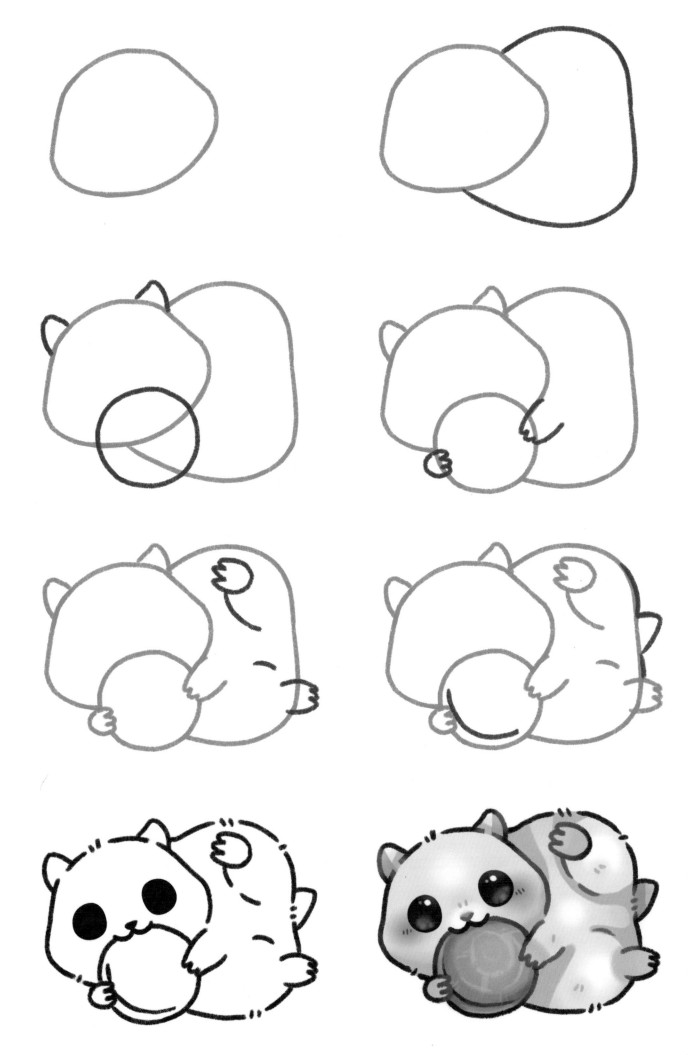

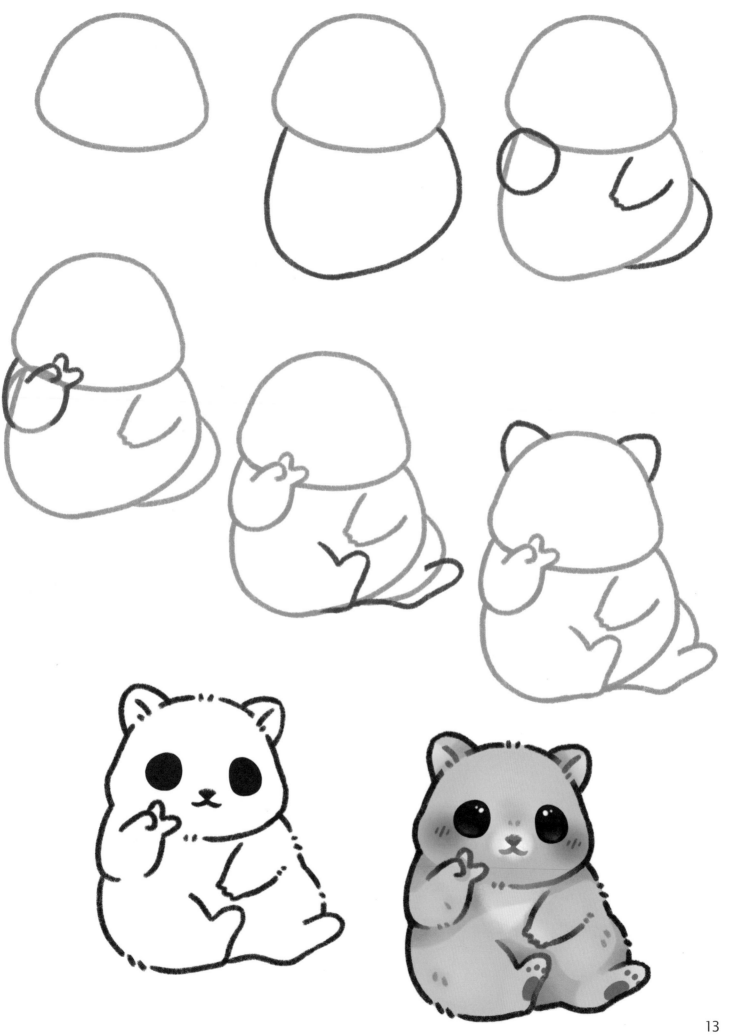

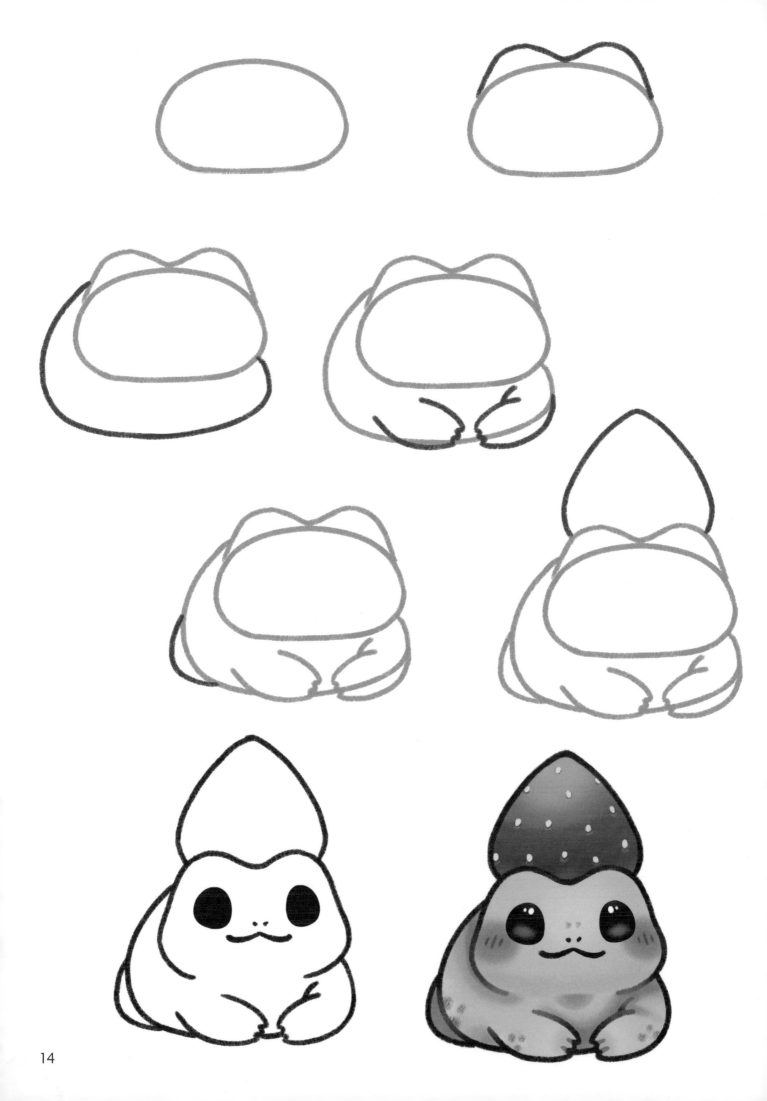

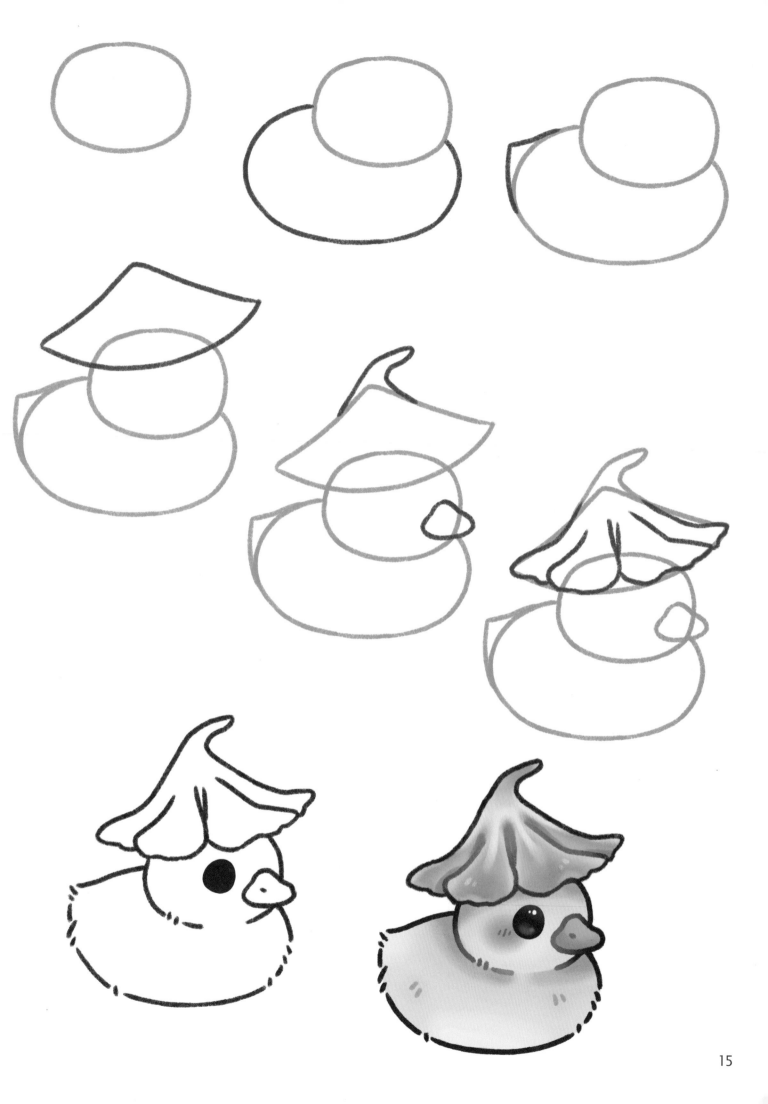

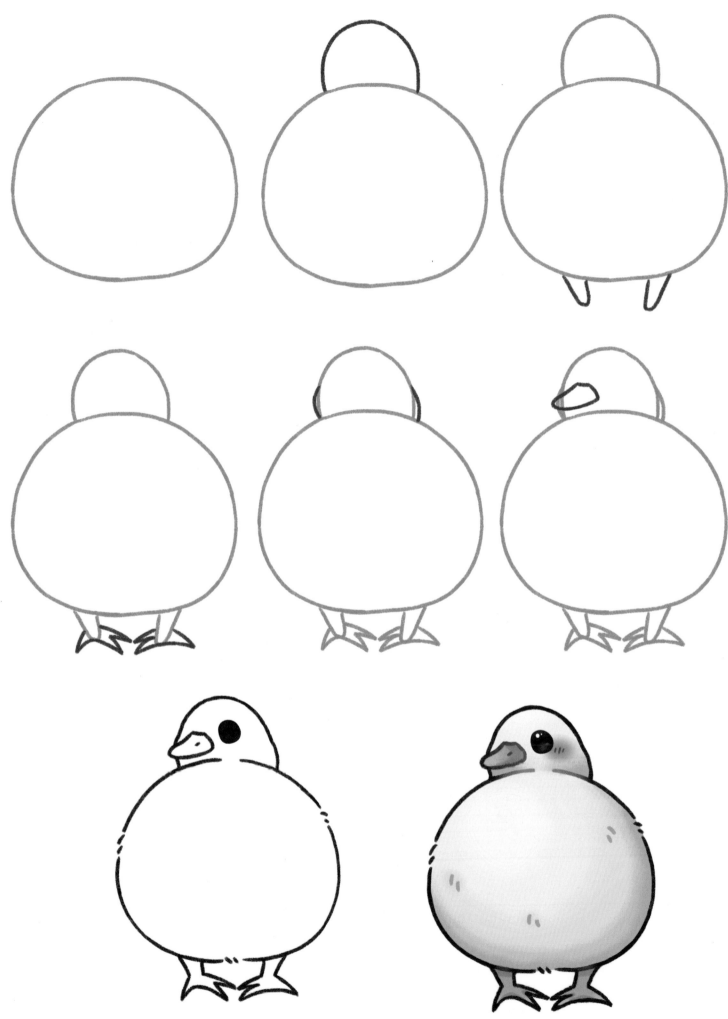

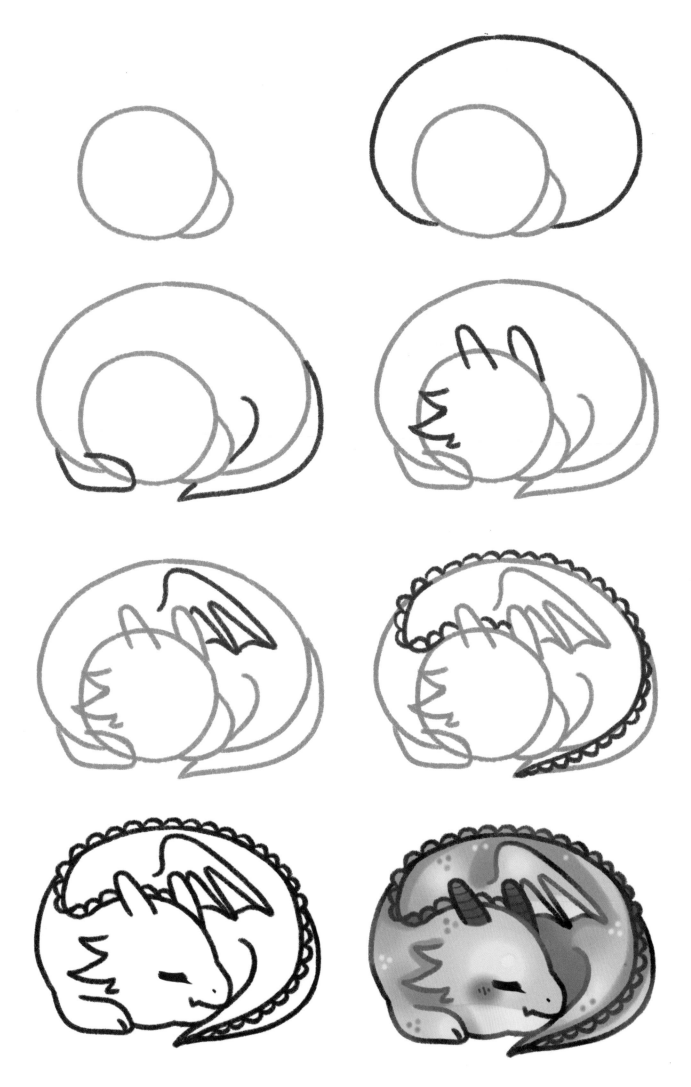

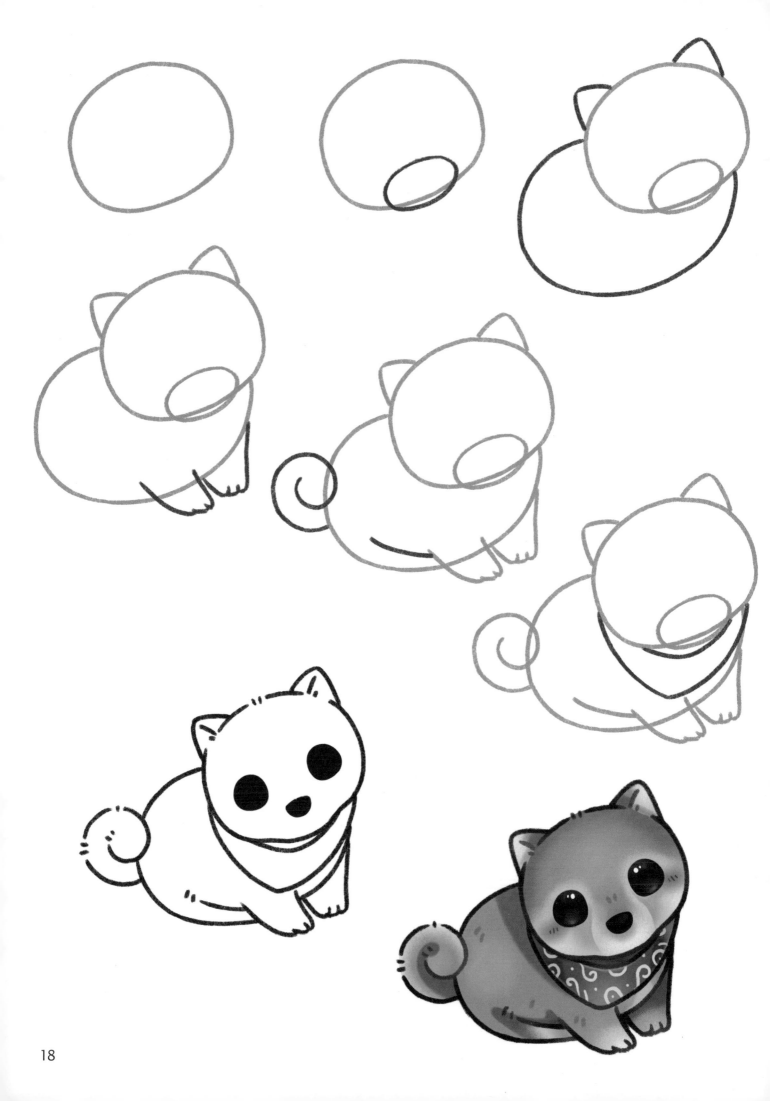

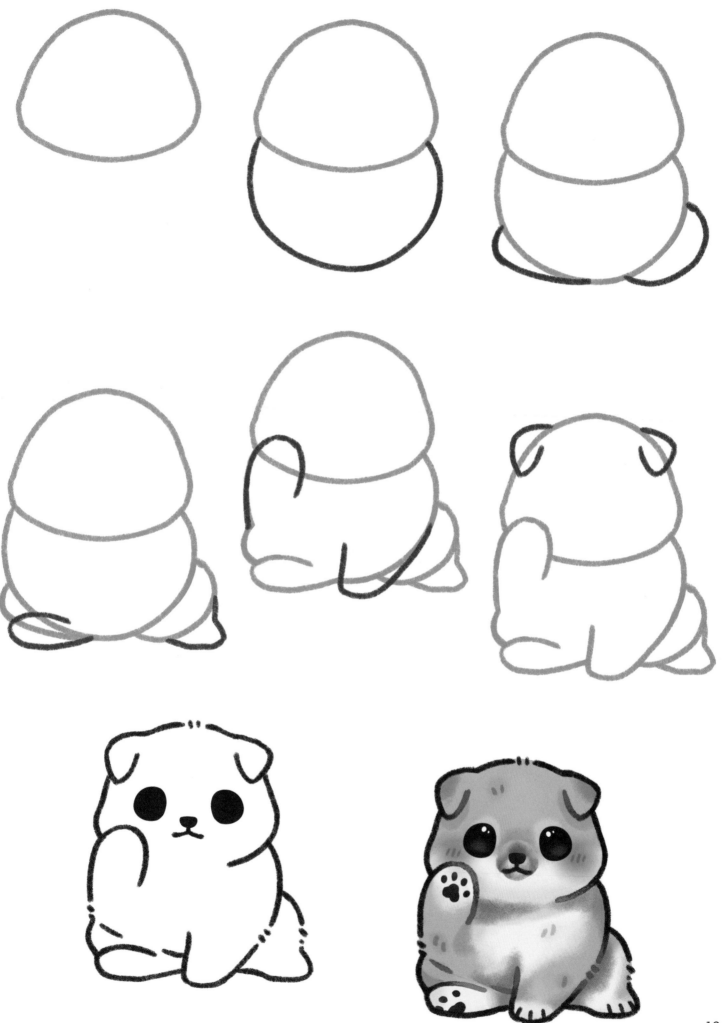

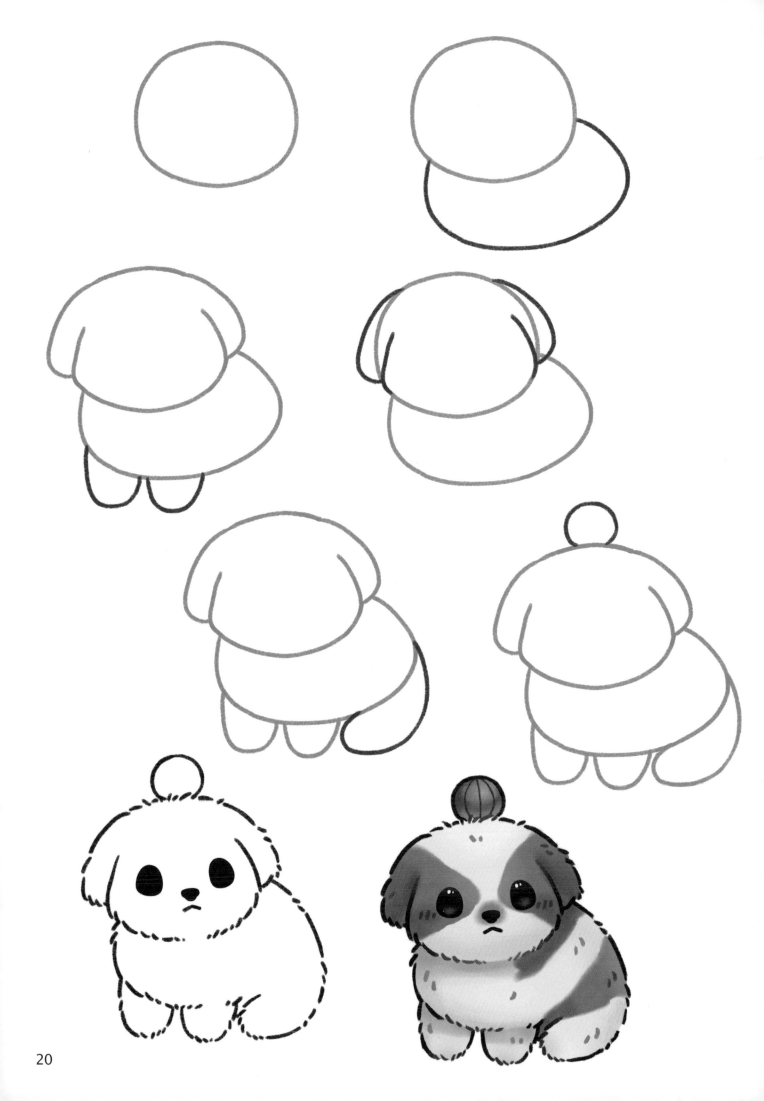

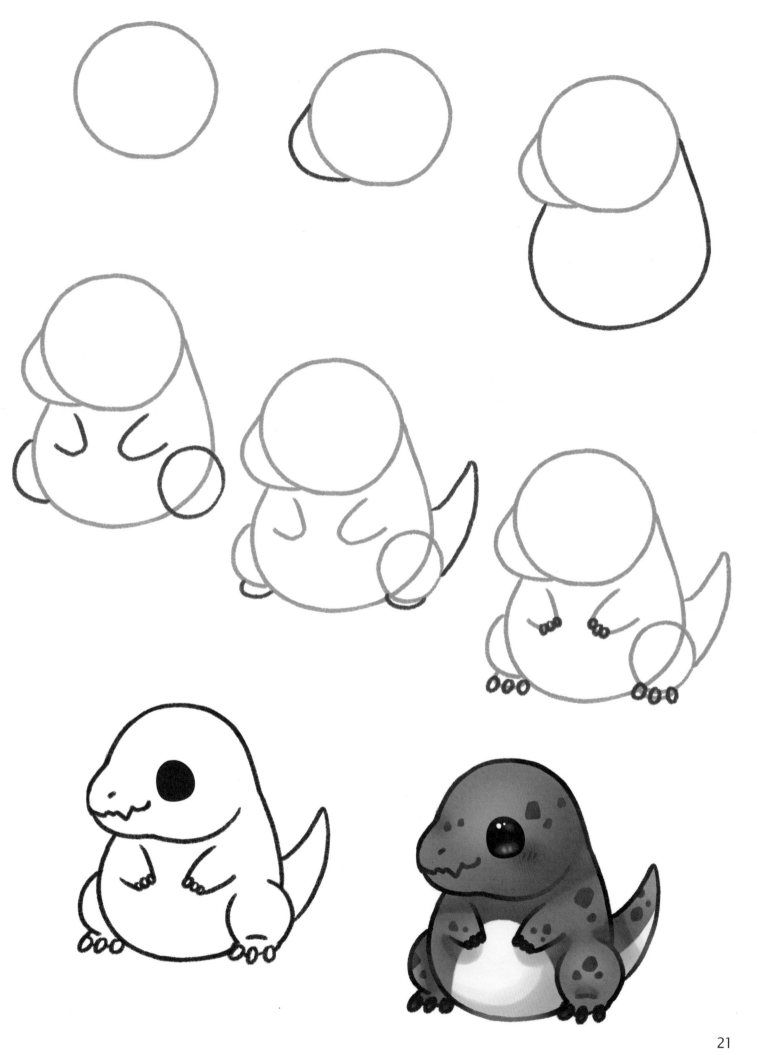

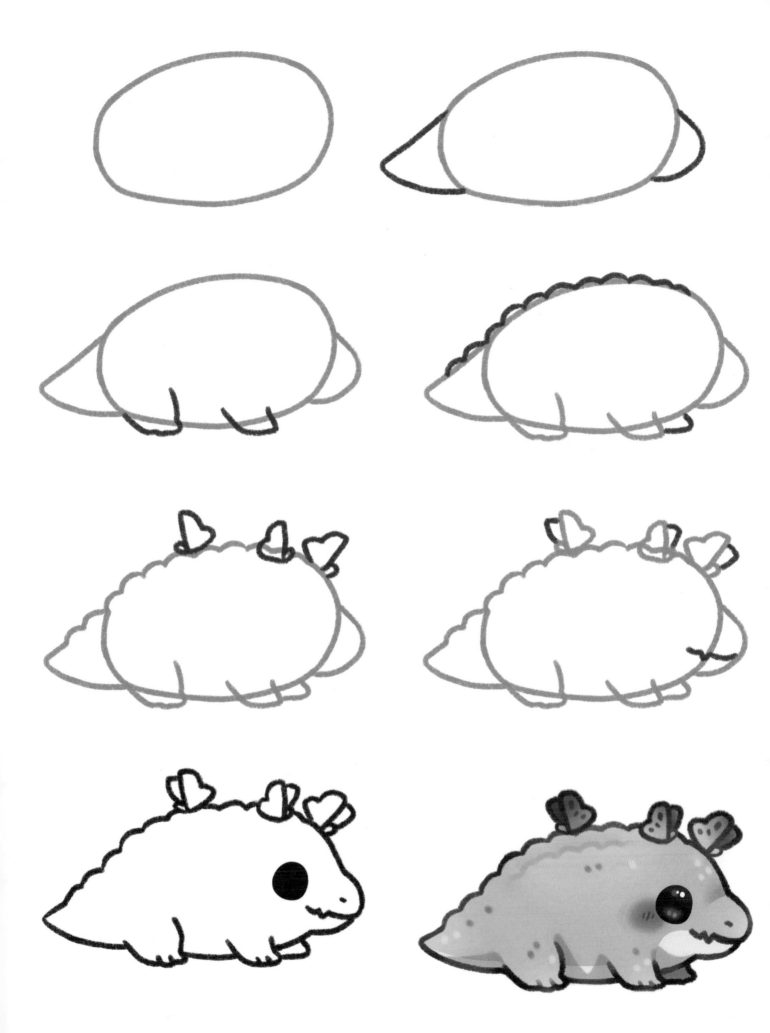

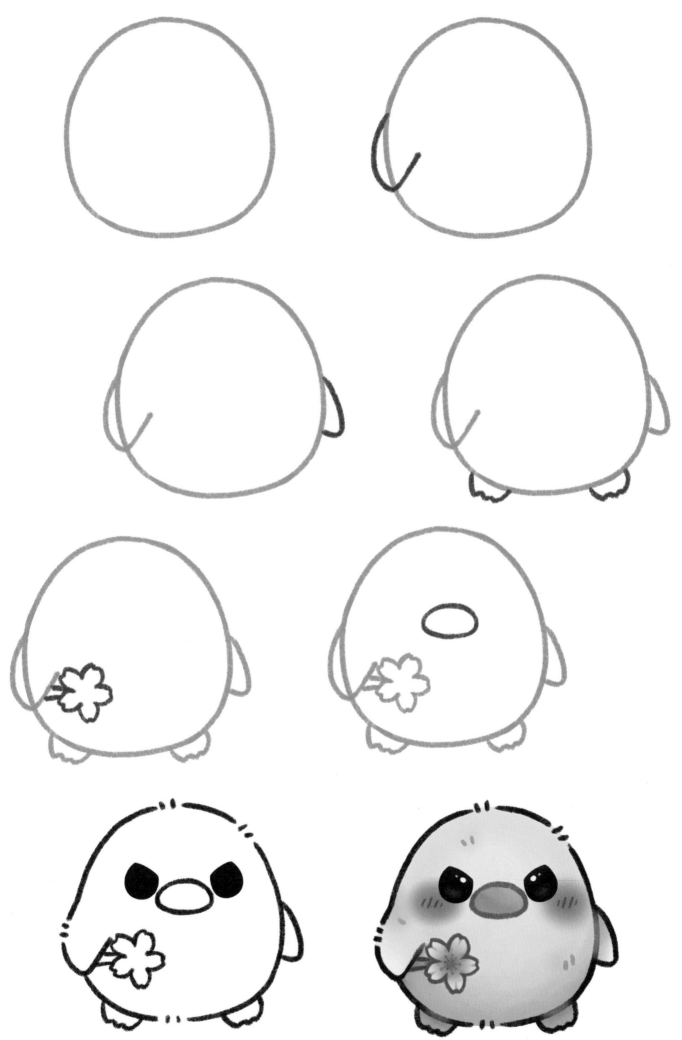

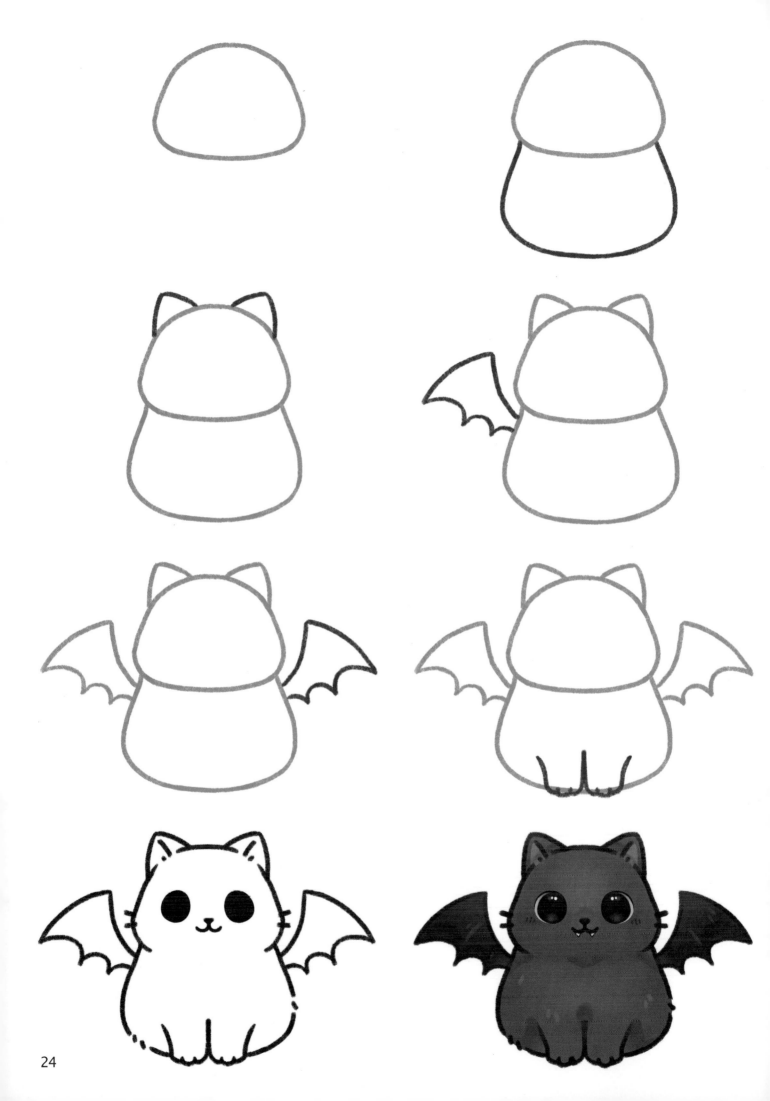

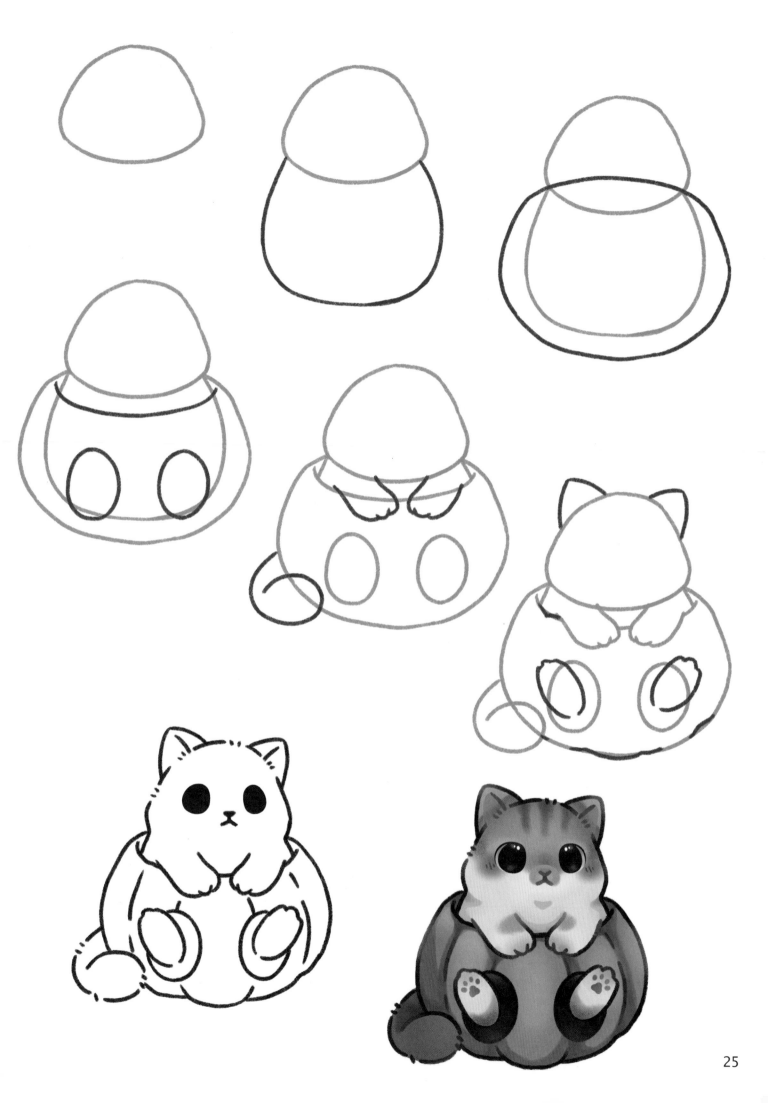

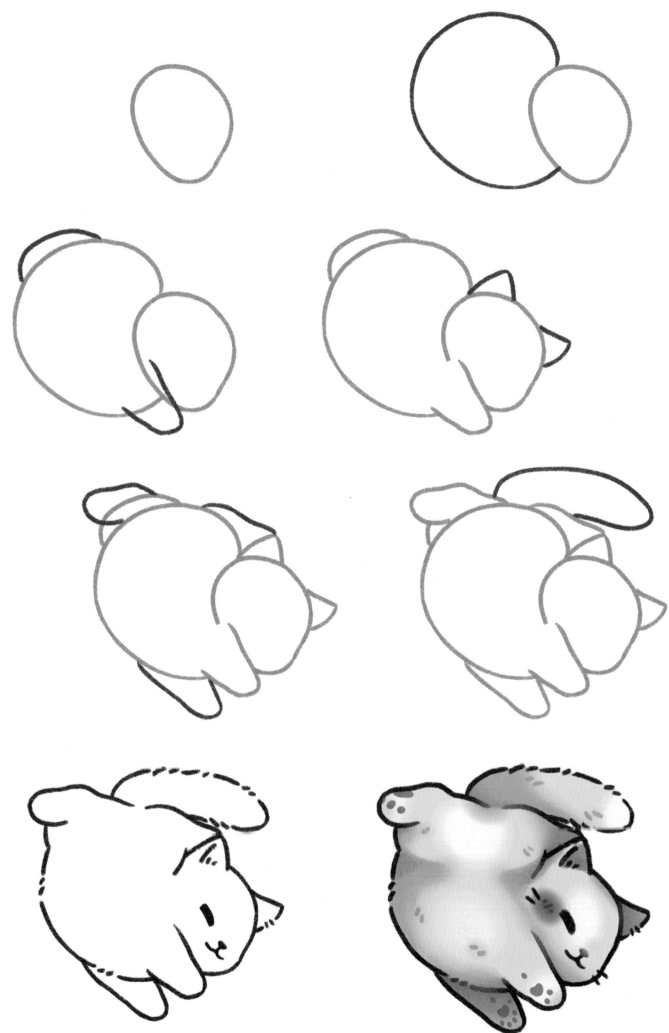

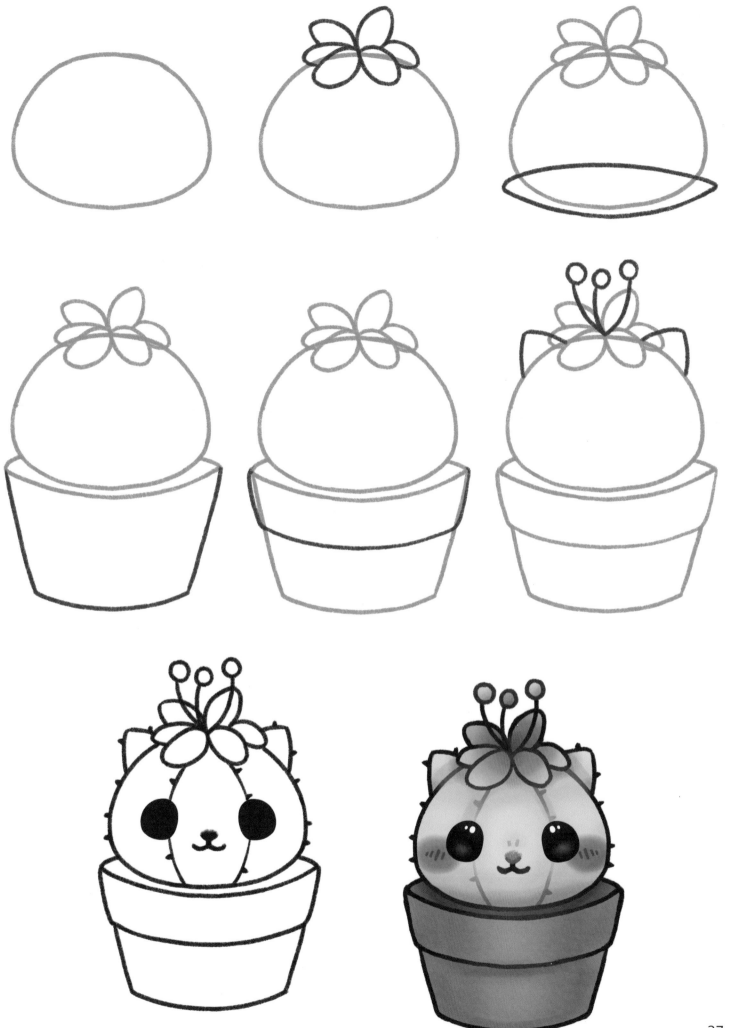

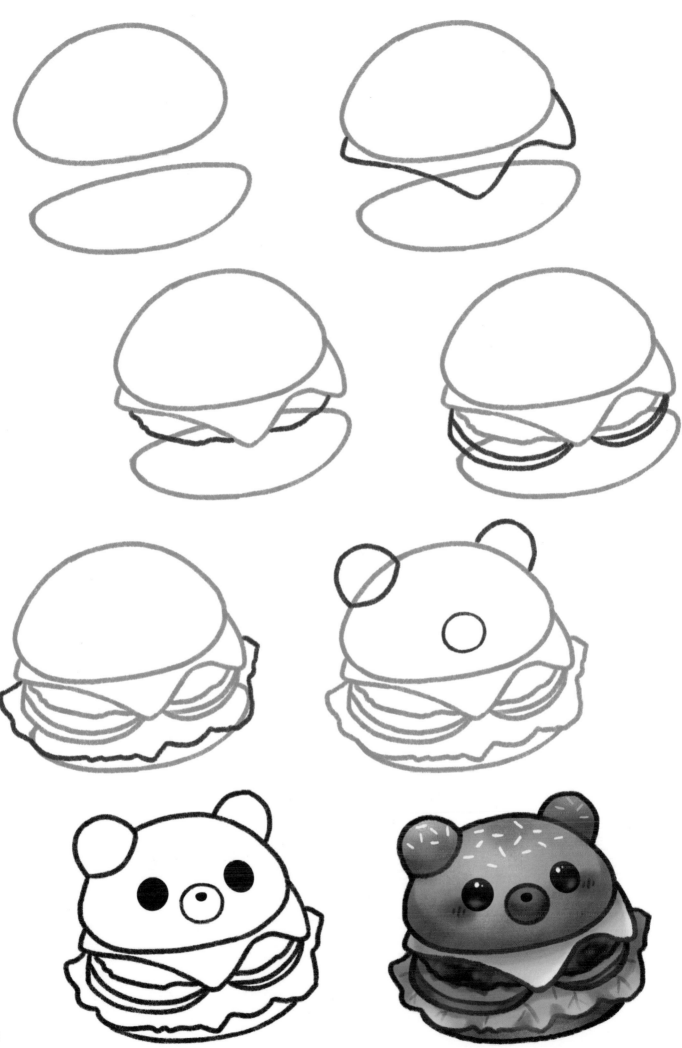

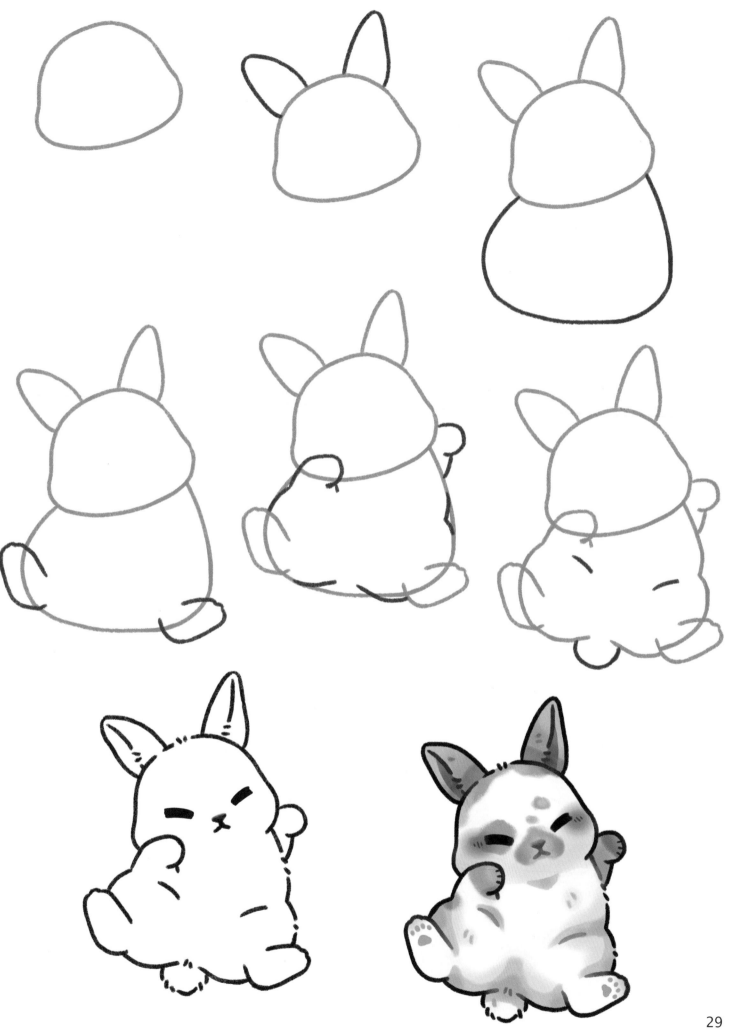

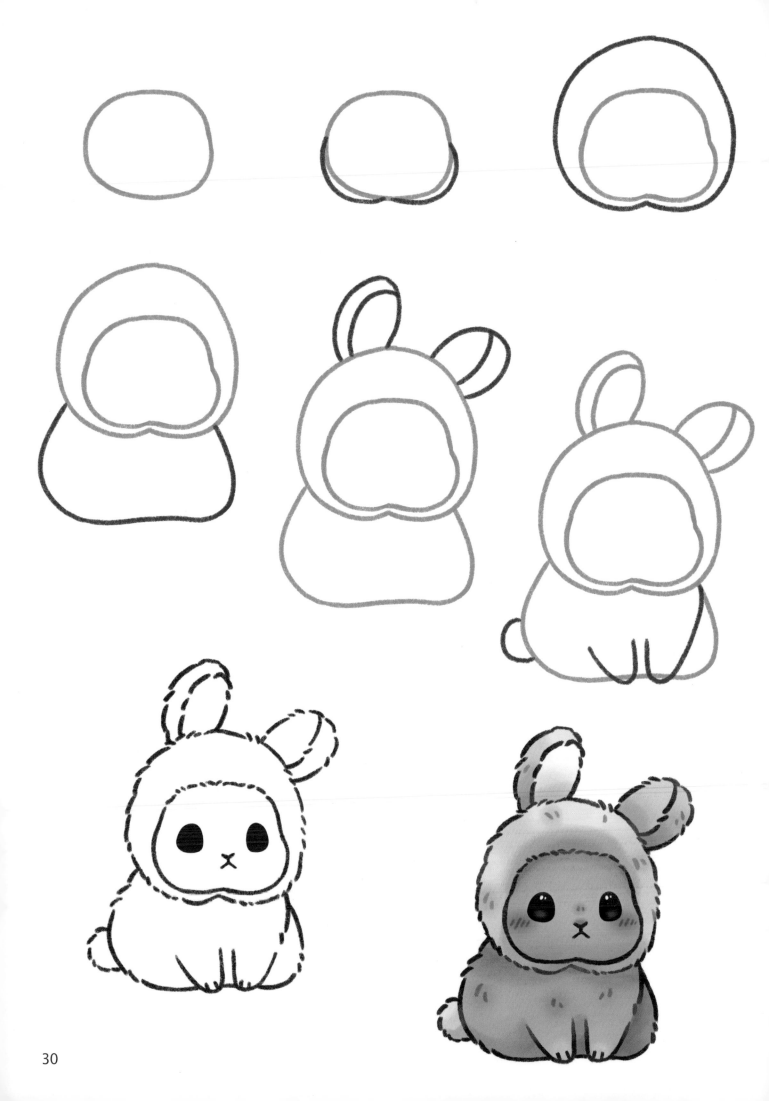

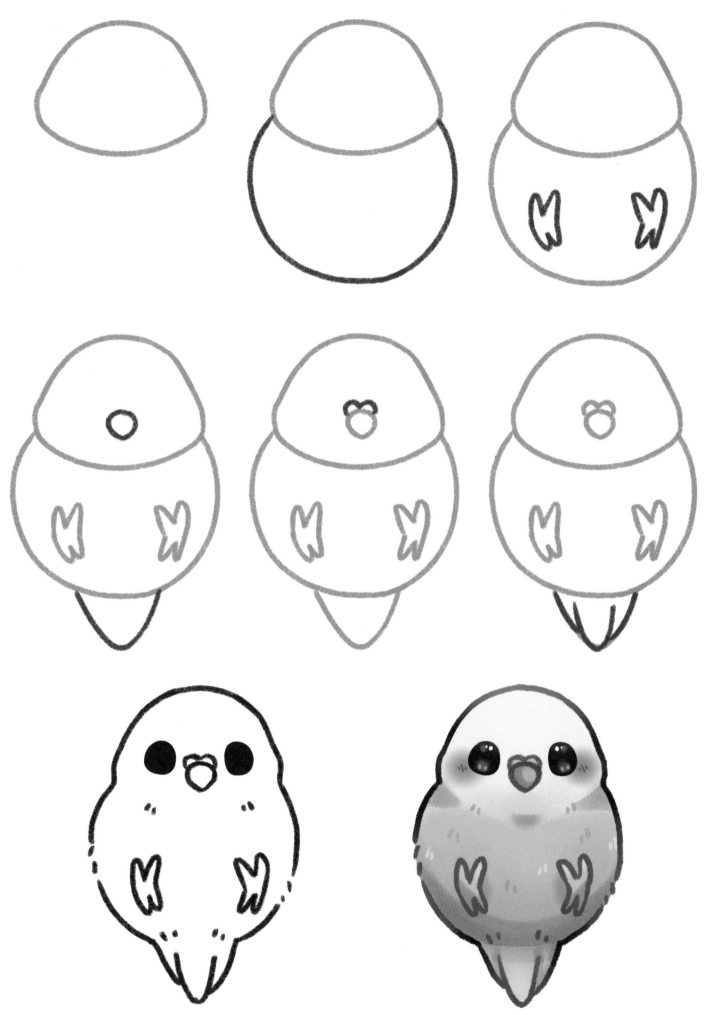

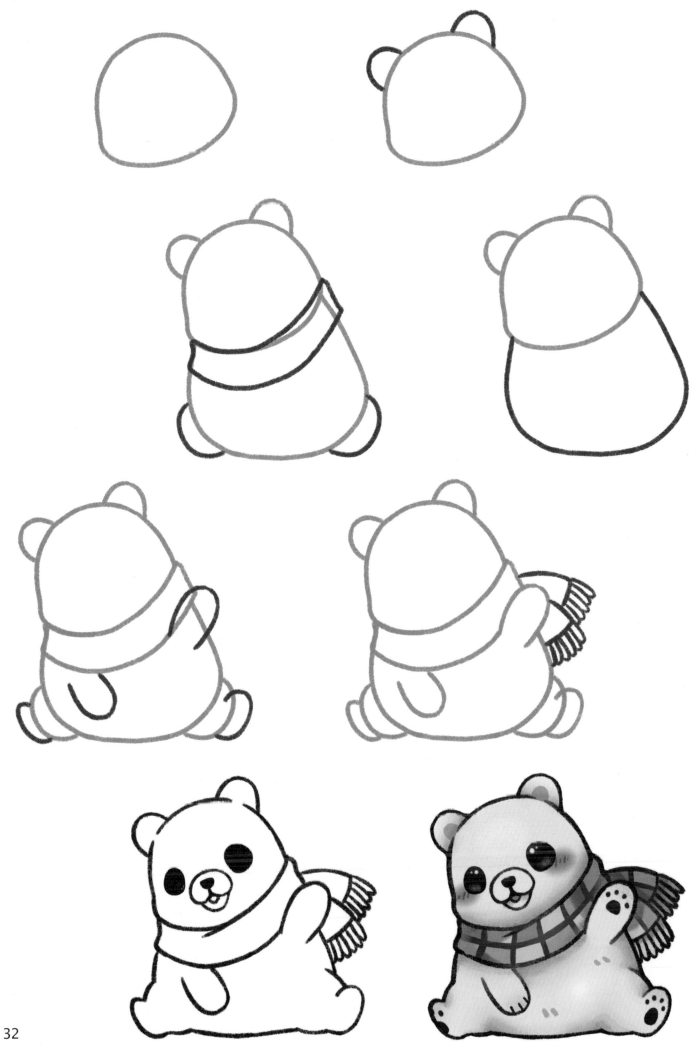